BEFORE THE DAWN

BEFORE THE DAWN

Bennett Obi

Copyright © 2014 by Bennett Obi.

ISBN: Softcover 978-1-4990-8791-8
 eBook 978-1-4990-8790-1

All rights reserved. No part of this book may be reproduced or transmitted in any form or by any means, electronic or mechanical, including photocopying, recording, or by any information storage and retrieval system, without permission in writing from the copyright owner.

Any people depicted in stock imagery provided by Thinkstock are models, and such images are being used for illustrative purposes only.
Certain stock imagery © Thinkstock.

This book was printed in the United States of America.

Rev. date: 07/09/2014

To order additional copies of this book, contact:
Xlibris LLC
0-800-056-3182
www.xlibrispublishing.co.uk
Orders@xlibrispublishing.co.uk
636230

CHAPTER ONE

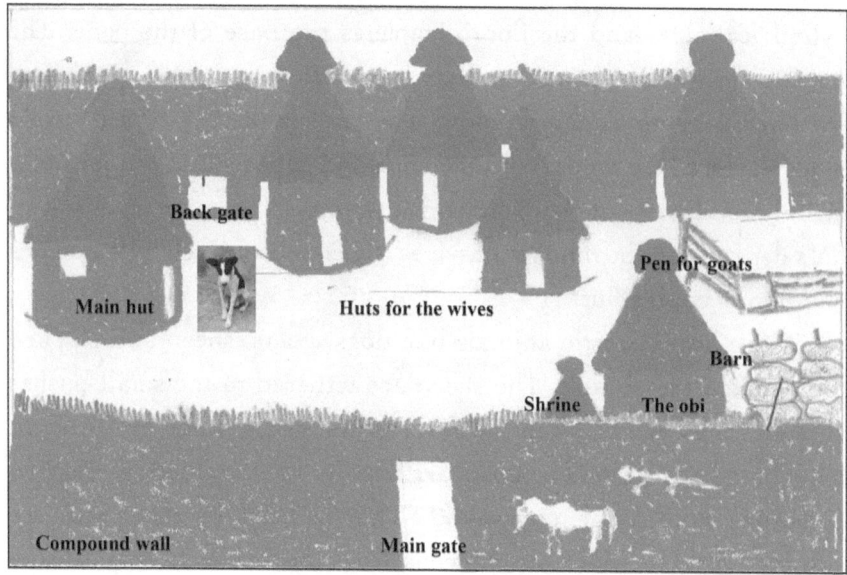

The home:

In the olden days in Igboland, the wealth of a man is measured by the size of his yam barn which in itself is a reflection of the size and strength of his family. Consequently every adult male would do all it takes to have a large and strong family (workforce). The home of a rich man could be identified from a distance by the number of huts it contains and the decorations on the walls surrounding the compound.

The decorations include paintings of big and powerful animals like the elephant, tiger, lion, buffalo, rhinoceros, crocodile etc. The inclusion of the painting of a cow signifies the compound of a titled man; that is a man that has been initiated into the prestigious *Nze na Ozo* society.

A village is made up many homes reaching up to hundreds in some places. Each home comprises the main hut that belongs to the man who is the head of the household, his obi (a small hut built in front of the main hut or outside the compound walls) where he receives and entertains his visitors. The wives' huts set in a haphazard manner behind the main house complete the home. Each hut is conical in shape with thatch roof forming the apex and the circular wall forming the cylindrical sides and the floor completes the base of the cone. The hut has only one entrance and a very small rectangular opening at the back serving as the window. The wall is built with semi solid mud plastered on wooden framework and allowed to dry properly or only mud without the wooden framework. The number of wives' huts depends on the number of wives the man has. Each wife and her children occupy a hut.

There are domestic animals like dogs, goats, sheep and chicken to complete the picture. The sheep are tethered in the small bushes surrounding the compound to feed on the grass. They are brought back home at sunset. The goats are usually kept and fed in a fenced enclosure within the compound. This is because the goats are considered to be more mischievous than the sheep. If they escape from the tether when they are tied outside of the compound, they don't come home straight; they destroy a lot of farm crops before they are found. The crops destroyed may belong to the owner of the goats or to the neighbours. The neighbour might react in an unpredictable way and the outcome may be disastrous. It might sometimes end up at the chief's court and the owner of the goats might be fined. This brings enmity between the neighbours.

So to avoid all these unwanted consequences, the goats are kept in the pen at home and the children have to gather fodder everyday to feed them.

The chicken, which are usually a few in number are left to feed within and outside the compound. They come home at dusk and enter their pen. The following morning they go out again.

All these animals are not reared for commercial purposes but to be used for food during festivals or to entertain visitors. However they are sometimes sold and the proceeds used to provide other family needs. The monetary unit was the cowries; not the cash that is in use today.

The dogs guard the home; they bark to alert the occupants when an intruder enters the compound.

A wall is usually built round the home to prevent unwanted intruders. There is usually the main gate in front of the compound and a smaller gate behind. The family members usually use the small gate for easy access to the gardens behind the compound to collect vegetables and things like that. They also use it if the man of the house is entertaining visitors especially strangers in his obi.

Polygamy is the rule rather than the exception, the more the wives, the more the children and invariably the richer the man becomes. A man's wealth is assessed by the size of his yam barn. So with a large workforce comprising many wives and children he is able to produce a lot of yam tubers. A yam barn is an enclosure in the compound where the yam tubers are staked on long palm fronds tied together to form a flat but upright support for the harvested yam tubers. These upright supports are arranged in rows inside the fenced enclosure. The fence is made by tying dry palm fronds horizontally onto the vertical supports placed at intervals along the line of the enclosure. These supports are usually obtained by cutting tree branches or small young trees. They are then planted in a row to make a rectangular shape. These branches survive and grow to become permanent structure that is used year after year for many years; only the palm fronds are replaced yearly.

This fence prevents the goats and sheep wandering in the compound from eating the yam tubers. The number and sizes of the yam tubers are used as a measure of a man's wealth. A man without a large barn is not well respected in the community.

The first thing that the man does every morning is to break kola nut that he offers to his ancestors to thank them for protecting his household throughout the night and also to request them to see him and his family through the day. He breaks the kola nut, eats a piece of it, throws another piece to the shrine, and the remaining he keeps for his early morning visitors (it is customary for the men to visit their neighbours first thing in the morning to make sure that everybody has woken up fine). He also offers his ancestors white chalk *(nzu)* by using the said *nzu* to draw a pattern on the ground depicting his kindred or his society if he is a titled man. If he does not have cola nuts he offers both his ancestors and his early morning visitors the *nzu*. The visitor picks up the *nzu* from a wooden plate and draws on the ground the symbol that depicts his kindred or his society if he is a titled man. The man of the house concludes his morning prayer by hitting his *ofor* (the symbol of authority) on the ground once. This ceremony is usually performed in front of his personal god *(chi)* represented by carved wooden dolls or moulded earth shapes, or short sticks arranged in rows on the ground. This shrine is usually situated near the compound wall and a few metres away in front of his obi. It is housed in a very small house-shaped structure resembling a dog house.

At the end of this ceremony, he retires to his obi to await the arrival of his wives and children, who as tradition demands must come to greet him before starting their day's activities. It is during this meeting that the man informs members of his family of his planned agenda for the day.

The women and children start their day by fetching water from the stream. They wake up early at cockcrow to go to the stream to fetch water. When they come back from the stream, they go up to the obi to greet their husband and father. Thereafter they sweep the

entire compound that has already been shared among the women, each woman and her girls sweep their own portion while the boys collectively sweep the road leading from the main gate of the compound to their boundary with their neighbours.

Usually one day of the four market days is reserved for the man. On that day all members of his family work for him in his farm. On the other days the women and their children work in their various farms. Women usually plant cassava, maize, beans, cocoyam, melon and vegetables in their portions of land. The family land around the compound is shared among the wives. When a new wife joins, the land is re-shared to accommodate the new wife. Any woman, whose portion of the family land is too small for her crops, can borrow a portion of land from a neighbour to plant crops for that season only. The borrower works in the farm of the lender for a specified number of days as a prize for allowing her cultivate the farm. The two people concerned agree upon the number of days she will work. Monetary payment is forbidden for such transactions.

Construction of the home:

The building of the huts and their walls is by communal effort. When a young man comes of age and he is planning to start his own family, he first of all builds his hut in the portion of land given to him by the community from the communal land. (However the first son as the heir apparent builds his house within his father's compound). It is the duty of the kindred to provide any young man with a piece of land on which to build his house. If the communal land finishes the kindred has to acquire land somewhere else for its young men. The young man intending to start his family has to inform members of his kindred officially that he needs a plot of land to build his home. He provides them with the items as stipulated by their custom and tradition and if they are satisfied with what he brought, then he is given a plot of land on which to build his house. The items presented to the kindred by the

requesting young man differ from kindred to kindred but in most cases palm wine, kola nuts, tobacco leaves, dry gin and food are included; cash is never included.

The young man intending to construct his new home clears the site after it has been allocated to him. He and members of his age grade or his friends start to gather the materials for the house construction. They start by gathering the grass that will be used to roof the hut. This is done during the dry season. When the rain comes his friends help him to prepare the mud that will be used for the walls.

This process of mud preparation is tedious and so he needs all the help he can get. To prepare for this, he chooses a place where the soil is mainly red laterite and not the blackish humus soil. He excavates the topsoil to create a wide but shallow trough where water collects when rain falls. He makes a gutter to channel water to this trough so that even with small amount of rainfall a lot of water collects in the trough. After the rain and if enough water has collected in this trough he goes into it and digs the surrounding earth into this water until semi solid mortar is formed. He could do this alone or with the help of his family and friends. He leaves the mortar overnight. The following day he and his friends go and carry out all the mortar from the trough; they mould the mortar into big balls of earth and take them one at a time and deposit them above the ground to form a big mound very close to the trough. After this first mud preparation the trough becomes larger and deeper. With subsequent rains and mud preparations the trough becomes a bigger trough that can hold hundreds of litres of water after rainfall. The mud preparation continues after every rain until they have made enough mud for the hut and the surrounding walls. This could take months to complete depending on the size of the proposed hut and the compound walls and also the number of people working.

The next stage of the preparation involves cutting the trees to be used in making the framework that holds the grass. They may go into the forest to cut straight long trees or cut down palm tree or coconut tree or any other big tree and split the trunk into long planks. There

are no saws to cut the tree or to saw it into planks; they use axe to cut down the selected tree and use a big hammer (wooden or metal) and a stout piece of iron shaped like the axe blade to split the tree trunk into planks. These axe-shaped implements are available everywhere because they are made by the local blacksmiths. To split the tree trunk, a shallow nick is made longitudinally on the trunk with a matchet and then the axe-shaped iron blade is driven into it using the hammer and this splits the tree trunk into rough planks.

The young men also gather twining climbers to be used as ropes to bind the sticks together during the actual construction of the hut because there are no nails to be used. The twining climbers are collected from the nearby forests.

When they have gathered all the materials to be used for the construction of the hut, a date is fixed for the actual construction of the hut. The actual construction involves every member of the community, men, women and children because everybody has a role to play. The young and strong men prepare the skeletal framework of the hut and prop it up on four or more big tree trunks that serve as pillars. Then while some people are on top of the hut fixing the grass others are building the walls. The women cook the food while the children carry the mud from the big mound to the building site. While some of the men are building the walls others make small balls of the mud for the children to carry to the building site. The children place banana leaves or cocoyam leaves on their heads and the men make the balls and put them on their heads; the older children use long but flat wooden trays to carry more than one mud ball at a time. When they reach the building site the builders collect them on their heads and they go back to collect more. Everybody continues to work until the work is completed or night falls.

The owner of the hut must ensure that enough food and palm wine is provided for everybody working there. He also provides snuff for those that may need it. Neighbours bring cola nuts to thank the workers. After the initial construction work is completed, the hut is left

for some weeks or months for the mud to dry up very well before the next stage of the construction. Nobody is paid any money for the work because whenever any person wants to build a hut others help him.

The remaining work on the house, which is flooring the house and the plastering of the wall is for the women. If the man is married his wife and her friends will do the job but if he is not married his sisters and their mother will do it. The women dig up laterite from the trough that was used to prepare mud for building the house and fill up the floor of the hut. They pour some water to make it stick together and ram it with long and flat bat prepared from palm frond. Thereafter they make semi solid paste from the laterite and use it to plaster the walls. This work may take many days or weeks depending on the size of the house and the number of people working. The floor and the wall are left to dry very well. When everything is well dried the women come to smoothen (polish) the wall and decorate the floor with green colour derived from crushed green leaves of a particular type of beans called *okwe*. The hut is now ready for occupation and the owner can move in any time he likes. The surrounding compound wall is constructed later. The top is covered with palm fronds to prevent rain water from soaking the wall and subsequently preventing it from falling.

CHAPTER TWO

Food production and food preservation:

Men usually plant their yam in the communal land away from the homes. Only a small portion of land in front of the compound is used to plant yam that is eaten during famine that follows after every crop is planted. This portion of land is cultivated very early in the season, in fact immediately after the first rain in the planting season (which is around the month of February or latest March). The yam mounds made after the first rain are covered with tree branches or palm fronds to protect the land from the searing heat of the sun during that time of the year so that the seed yams do not rot. When enough rain has fallen, planting of the rest of the yam and cocoyam commences. Cassava is planted at the beginning of the dry season as it does not thrive well in rainy season. Ploughing of the farmland or making of the mounds is done using the hoes and the type of hoes in use is the one that has short handle and that means that the person using it has to bend down very well to work. This is very tedious and tiring and exerts severe stress on the waist.

Earlier in the rainy season after planting the yam around the home, the community selects the portion of the communal land that is to be cultivated that year. A few young men (about four or five of them) are nominated to go and apportion the land according to the number of

homes in the community. The oldest man in the kindred gets two plots of the land to cultivate his crops. He can sublet part of it to younger people that need more land for their crops. After the sharing of the selected communal land, anybody can start work on his portion any time he chooses. Land preparation usually starts immediately after the demarcation of the plots while waiting for more rainfall before yam planting can follow. The land to be cultivated is normally left fallow for a few years and so by the time it is to be cultivated it has become a small forest of shrubs and few trees.

Land preparation is the easiest part of the farm work. The undergrowth is cleared first leaving the trees and shrubs for the later stages of the preparation. In this way work is done under the shade provided by these trees. During work, lunch is prepared in the farm by the women or girls as the case may be and in almost all occasions yam is boiled and eaten with red palm oil garnished with shredded or ground fresh pepper. Clay pot is used for the cooking of food because that was the only type of pot available then. The yam is normally boiled without peeling off the skin and after cooking the cooked yam is spread out on the leaves laid on the ground for that purpose. Palm oil is put in a plate-shaped earthenware dish *(oku)* or wooden plate *(okwa)*. The workers then gather around, peel the yam portions, dip them in oil and eat. The drinking water is collected in a gourd from home when coming to the farm or from the stream if the farmland is near the stream. After food the workers rest for a while before resuming work. During this rest period some people take a nap and some others engage in conversations. Work resumes after about thirty minutes rest. At the end of work in the evening the workers return home.

At home while women and girls go to the kitchen to prepare supper (which is usually pounded fermented cassava with palm nut soup), the men entertain themselves with some palm wine and snuff or any other available item in the man's obi. If on the other hand it is only the man of the house that went to work with his family he waits patiently in his obi for the supper to be prepared and served. After supper the

women may tell the children some folklore or the children may play in the compound especially when the moon is shining. If the children are playing the women may engage themselves in some gossips. The household retires for the day at the end of all these activities.

Land preparation continues until all the undergrowth is cleared, and then the tree branches are cut. The farm is left for some four to five days for the leaves to dry up and then the farm is then set on fire. After burning the farm, women and children gather all that is left by the fire and put them away in the surrounding farmlands. The land preparation is completed and planting commences after enough rain has fallen to soften the ground. The man, like the woman can borrow portions of land from his neighbours if his share of the communal land is insufficient for his need.

Apart from a man working with his family, he can also team up with some men of his age grade and they work in rotation. The number of men forming the team is variable; it depends on the number of people in the community who think that they are of the same strength in farm work and that they can also work together. They work in one person's farm on one day and on another day they work for another member and they continue like that until they have gone round all the members and then another round commences. When they are working for a member, that member has to feed them three times in the day. The women prepare the breakfast at home and send it to the workers in the farm. Lunch is prepared and served in the farm. Supper is eaten at home when the men return from the farm. The food for these men is usually very sweet because a lot of smoked fish is used to prepare it.

When rain has fallen enough to soften the ground, cultivation of crops begins. While men plant the yam, the women plant their cocoyam on the days they are not working for the man. During the planting of the yam, the seed yams are brought down from the barns and carried to the farms in long cane baskets called *ukpa*.

Cane basket (Ukpa)

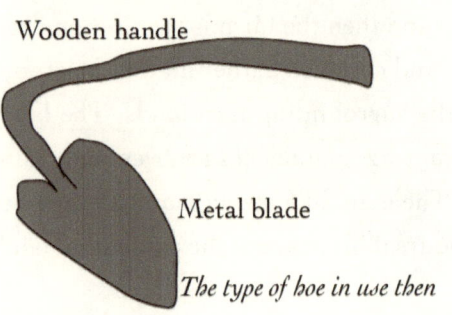

Wooden handle

Metal blade

The type of hoe in use then

Conventional round basket

Yam is not carried in the conventional round baskets as that is regarded as belittling the status of the yam; only cocoyam is carried in the round baskets. The women and children carry the yam on their head and the journey to the farm is made on foot as that is the only available means of transport. Yam is planted singly in small mounds. The man determines the size of the seed yam to be planted because he uses a sharp knife to slice the yam into small pieces as he pleases.

Breakfast and lunch are cooked and served in the farm as it was the case during the land preparation but supper is prepared and eaten at home after work. After planting the yam, which may take many days or weeks depending on the number of people working and on the size of the farm, the women plant maize and melon in between the mounds. The maize and the melon fruits mature and are harvested within three months before any harm is done to the yam. Yam is a tuber that grows underground but the stem is a climber that needs support to climb up where it can receive a lot of sunshine that helps in the manufacture of the food by the leaves. It is the food that is manufactured in the leaves that is stored as tubers underground. So when the yam germinates stakes are used to prop up the stem

so that the leaves can receive enough sunshine. These stakes are collected during the land preparation. From the planting of the yam to its maturity takes about six months. The farm is usually weeded twice before the yam is left to mature and be harvested. Women and children weed the farms; men are not involved except in very rare cases of lonely men without a wife or children.

After weeding the yam and cocoyam farms the women start planting cassava towards the end of the rainy season. Cassava does not require much rainfall; in fact too much rain withers the cassava cuttings and prevents them from germinating. Cassava stems are cut into short pieces of about twenty centimetres and planted on the big mounds; up to five or six cuttings can be planted on one mound.

Cassava takes one to two years to mature. People that have enough food leave their cassava for up to two years before harvesting but those without much food at home may start harvesting theirs after one year.

Yam is harvested when it is fully matured and the stem dries up. Yam is tuber and so has to be dug out from the soil during the harvest. Men usually dig out the yam while women and children carry it home on their heads. The yam is staked in the barn and covered with palm fronds to protect it from the direct heat of the sun; direct heat from the sun causes the yam to rot.

The cocoyam is harvested and heaped together in small mounds in the shelter provided at one corner of the compound or under the trees near the house. The risk with leaving them outside the compound under the shades is that stray sheep and goats can eat them.

The grains like the maize and beans are sun-dried and stored in calabashes; ground dry pepper is added to prevent weevils from destroying them. The family eats from these stored food items till the next planting season when the left over crops are planted.

Apart from farming, some men are wine tappers in addition. They tap palm wine from numerous palm trees in the village or they tap from the raffia palm trees that grow in the riverbanks far away

from where the people live. These rivers are distributaries of the well known River Niger.

Palm tree can be tapped over and over again but the raffia palm is tapped only once. The growing shoot of the palm tree is spared but the shoot of the raffia palm is cut and so it dies after the tapping.

The men that tap from the palm trees at home climb each palm tree three times a day to clean the surface from where palm wine oozes out and if it is not done like that the palm wine ceases to flow out. The palm wine collects in the calabash that is placed up in the trees for that purpose. The palm wine tappers have a way of fixing the calabash so that drops of palm wine can collect into it; they don't just tie it anyhow otherwise palm wine will not collect in it. The wine tappers climb up the palm trees every morning with another calabash to collect palm wine from these calabashes on top of the palm trees. The palm wine that is collected is diluted and sold or kept at home to entertain friends and neighbours. The wine tappers tap their wine early in the morning before going to the farm on the days they go to the farm and they also take time off from work to go and tap the trees in the afternoon. The evening tapping is done after farm work. The wine that is collected in the morning can be given to one or two of the children to go and sell while the man and his wives and the other children go to the farm. The children that go to sell the palm wine join them in the farm later or may be given other assignments to do at home especially if the farm is far away from home.

The people that tap from the raffia palm trees in the riverine areas leave home at cockcrow to be able to finish in good time to sell their wine and go to their farms. Most of the raffia wine tappers have their farms in the riverbanks. The tappers of the raffia palm climb the tress twice a day to clean the wine surfaces. They go to these places in canoes and bring out their palm wine in large clay pots at the waterfront to sell it. Traders from neighbouring communities usually buy the wine to sell in their communities that do not have access to the river. It is obligatory for any palm wine tapper to bring home a

large quantity of palm wine when he comes home in the evening. His neighbours gather in his compound every evening to drink free sweet palm wine and bless him so that the ancestors continue to protect him day in day out.

Feeding of the family:

Feeding the family is regarded as the responsibility of the man. Any man that cannot provide adequate food for his family is not well respected. Women however support the man in as many ways as they can. Since the man grows only yam, it means that women contribute the missing parts of the family menu. Yam is eaten at lunch most of the time but cocoyam is used to supplement if the quantity of yam provided is small. That means that the man provides only part of the lunch sometimes while the women provide breakfast and supper. That invariably places the onus of feeding the family on the woman even though the community doesn't see it that way. The wives take turn to cook for their husband but when a woman gets old she is exempted from this job. She cooks only for herself and her children if they are still young and living with her. That does not preclude her from the share of the yam for lunch.

Every morning before the man goes out of the house to his farm or for hunting or for fishing or to any other place, he gives each woman yam for their lunch. If he comes back from hunting or fishing, he shares out the meat or fish as the case may be to the wives. The wife that feeds their husband on that particular day gets the biggest share of the meat or fish as the case may be; that same woman also 'owns' the man for the whole day and night.

Food is cooked in clay pot over a tripod of mud bricks, and firewood is the source of energy for the cooking. When cooking food for a titled man certain rules must be observed. In the first place when cooking the food that a titled man eats nobody is allowed to crack palm kernels in that kitchen. While the food is still on the fire

nobody moves firewood from one sector of the tripod stand to another; neighbours are not allowed to take fire from the stand. (Usually people go to their neighbours to get fire because matches were not available. People usually preserve their fire by putting big logs of wood in the fire to smoulder for days, weeks or even months). The woman cooking the food must not raise her voice in a quarrel with another woman while cooking the food but if she does she must bring a hen to appease the gods that she is deemed to have offended.

The man is served in his obi. The soup is served in a clay pot (*oku*) while the food is served in carved wooden plate (*okwa*). The breakfast is usually pounded fermented cassava (*foo-foo*) left over from the previous night.

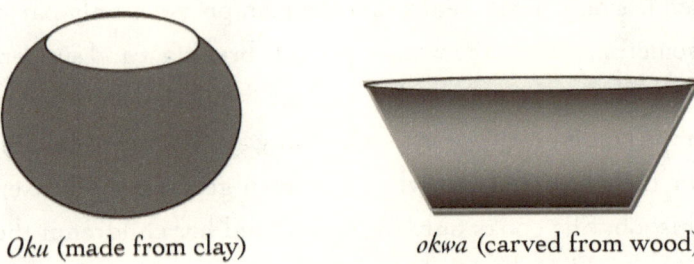

Oku (made from clay) *okwa* (carved from wood)

To get the fermented cassava, fresh cassava tubers are soaked in water in a pot and left to stand in the sun for about four days; the fermented cassava is then crumbled with hands in clean water in a wooden mortar or large-mouthed calabash or clay pot and sieved with a small basket prepared for that purpose. The starchy precipitate that forms is left in a bag to drain out the water. The solid paste that is left is used to prepare the *foo-foo*, which is the main food for supper everyday. The left over *foo-foo* from the previous night is warmed and eaten in the morning before anybody goes about his or her daily activities. The man warms his soup over the fire in his obi, and that is why his soup is served in a pot. He could however ask any of his wives or children to do that for him. Children normally eat together from a big wooden plate (*okwa*) or from the wooden mortar (*ikwe*).

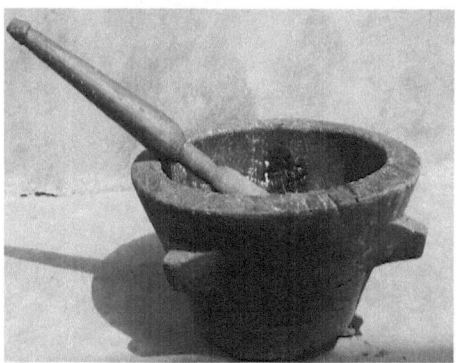
Mortar (Ikwe) and pestle

Before they start eating their food, they remove any pieces of meat or fish in the food and keep them aside. After eating the food they share the meat or fish and the eldest child takes a portion first, then the next in line takes another portion and they continue like that until the youngest child takes the last portion. After eating, the *okwa* is usually not washed but rather a blunt kitchen knife is used to scrape away any food remnants adhering to it. The same thing applies to the wooden mortar, only the *oku* is washed after eating. This is probably because trying to scrape something from the clay pot could break it. After this, the *okwa or ikwe* is covered upside down on the floor of the hut or in some cases they are stowed away upside down on the rafters or incomplete ceiling (*akpata*) of the hut.

Fruits are usually in abundance every time of the year. Anybody can pluck the fruits from any tree in the community and eat. The fruit trees are not owned individually. They are not planted; the seeds thrown away after eating germinate and grow into trees and so traditionally nobody can claim ownership of any fruit tree.

CHAPTER THREE

Village market:

The main occupation of the villagers is subsistent farming, but some in addition engage in petty trading. They trade mainly on groceries like salt, dry pepper, smoked fish, ground tobacco (snuff), rice, beans, palm fruit, plantain, banana, vegetables etc. Market Square is located in the centre of the village. It is usually located under a big tree that provides shade, but there are small thatch houses built by individuals for their own use. There are no lockup shops. People start gathering for the day's business by midday after they have been to their farms and back. They display their wares on the mats spread on the ground, but a very small minority can afford wooden tables to display their wares. Bartering is the main mode of trading but a small number of people use cowries to pay for their purchases. Those people were regarded as rich. A lot of people buy goods without money promising to pay later. This is common practice because the villagers know one another and where anybody could be located if need be. Many of them delay to pay or refuse to pay at all. When such happens mothers send their children to go and collect those debts, but sometimes quarrelling ensues between the women. The quarrel may sometimes drag to the court of the village head. It is the responsibility of the chief to see to it that the matter is settled amicably. He makes sure that the debtor

settles her debts; he employs his wisdom and diplomacy to get things done without any party being offended. Any chief that rules like that is very well respected by his people.

The salt that is sold in the market is not the salt granules we are used to these days. The salt is baked over the fire to make it hard. Before baking, the salt is first of all mixed with water and moulded into different shapes and sizes using coconut shells. The moulds are placed on flat metal sheets and dried over strong flames. When anyone wants to use salt, she uses a knife to scrape the quantity she needs. The remaining portion is placed near the fire to keep it hard all the time. Sometimes a stray goat from the pen might eat the salt where it is left near the fire to harden.

Apart from these groceries, fruits from cash crops are sold in the market. Most common ones are kola nuts, palm fruits, plantain, banana, breadfruit, bitter cola, castor oil seeds, oil bean seeds, etc. Palm fruits are valued very highly because they are processed to get palm oil that is used in cooking and frying (though frying was not much in use those days). Others like breadfruit, oil bean seeds, plantain form a major part of food that is eaten in the village. Bitter cola is used to dye fabrics even though people still consume a small portion of it. Kola nut occupies a special position in the culture and traditions of the people. It is used to offer prayers to the ancestors whenever and wherever the villagers gather for any function. It is a sine qua non in performing many traditional rites as would be seen later in this write up.

Some other fruits like mangoes, oranges, pears etc are not usually sold in the market. They are regarded as fruits that children eat on the streets when they run errands. Anybody selling them is regarded as wretched, miserly or outright wicked and to make matters worse those fruits don't even fetch much money because practically everybody has got them around his compound.

Business at the market is usually over at dusk because there is no light to use when it is dark, although in some communities they use

hurricane lamps to continue late into the night. Any good mother must buy something like peanuts, fried bean cake (*akara*), *mai-mai*, etc for the children at home every time she goes to market. The children look forward to those gifts whenever their mother goes to market. Even a barren woman buys gifts for children in the compound, because children are said to belong to everybody. Those children in return help the barren woman to collect firewood from the bush and fetch water from the streams. When mothers return from market children gather to share the gifts. This is usually done on banana leave spread on the floor. The youngest among them shares whatever is bought and the oldest takes a portion first and others follow suit in descending chronological order of age.

Water supply:

The main sources of water supply to the community are rainwater and the streams, which are many in this village probably because of its proximity to the river Niger. The community lies in the plains of the Lower Course of the river Niger; at its lower course the river Niger has many distributaries and some of them flow throw this community. During the rainy season, rain water is collected and stored in large earthenware pots that stand majestically around the huts. There is no pipe-borne water or deep bore holes. When the rain is not there (especially in the dry season) people use calabashes and clay pots to fetch water from the streams. They go very early in the morning before daybreak and the first person to reach the stream throws some object into the stream and utters some words to warn the night spirits that the humans have come and that they should go away. It is believed that the spirits come to fetch water at night when the humans are asleep. It is believed that if the first person did not perform that ritual, evil might befall her that day. It is however difficult to know the first person to reach the stream so in case of doubt to avoid the wrath of the spirits anybody that feels that she is the first person performs that ritual

because performing the ritual more than once in one morning attracts no punishment. A person assumes that she is the first person if she did not meet anybody on her way to the stream early in the morning. It is also believed that if that ritual is not performed a particular type of snake called *oḍi mmiri* will disturb the people fetching water from the stream that day. So any day that a lot of *oḍi mmiri* are seen in the stream people believe that the first person to reach the stream in the morning did not perform the ritual.

CHAPTER FOUR

Marriage

When a young man decides to get married, he tells his parents about his intention to get married. His parents then send messages to all their relatives far and near to look for a wife for their son. (Interestingly relatives don't live far from one another because they don't go to the cities to work or trade; they are all village farmers, fishermen, wine tappers and hunters that live in the villages). It is important to mention here that a man is not permitted by tradition to marry from his kindred; he must marry from another kindred. The relatives that are informed look around in their neighbourhood to find a well-behaved girl and invite the young man to come and see if he likes her. The young man visits the identified places either alone or accompanied by a friend or two. The girl in question will be informed by her parents to behave well to their visitors to enhance her chances of being chosen. Sometimes the young man is impressed by the first one he sees and settles for her or he may have to visit many homes before making his choice. Another way of choosing a wife is by betrothal in which case a young girl is betrothed to a young boy at her birth. That is to say that the parents of a boy approach the parents of a new born baby girl and tell them that their son will marry their daughter when she grows up. If they agree, a ceremony is performed to seal

this agreement. The boy and the girl grow up knowing that they are going to get married in future. This method has many disadvantages because sometimes the boy or the girl grows up into what was not expected but because of the betrothal the marriage must go ahead even though both parties are displeased.

When a girl has been found, a date is set aside for the introduction ceremony. On the appointed date, the young man and his father (or another elder relative if his father is deceased) take a few relatives and pay the girl's people a visit. This visit is usually in the evening. They must go with a keg of palm wine and some cola nuts (seven or eight). They present them to the girl's people and tell them their mission. The girl is called to greet their visitors after which she goes back to her mother in her hut. The men drink their wine, eat the cola nuts and depart. This visit is called "knocking at the door" *(iku aka n'uzo)*. The girl's parents in turn make inquiry about the man and his parents. If they are satisfied, message is then sent to them to proceed with their mission, but if they are not satisfied, no message is sent. If the man waits for two market weeks (about eight days) without receiving any messages, he knows that the mission has failed. The girl and her people have rejected him. He now looks for another girl to marry. Things that can lead to the rejection of a man from marrying a girl include laziness, drunkenness, brutality to women, somebody of questionable character or being an "outcast". In this community there are people regarded as outcasts. Their great grand parents were dedicated to idols. In other words they are married to the idols and so cannot intermarry with the free born. They can only marry among themselves.

When both parties agree, real marriage ceremony begins. It takes many visits to conclude a marriage. During the first visit, the man and his people go with kegs of palm wine and cola nuts as was in the case of "knocking at the door" only that this time more people are involved and more kegs of palm wine are carried. The people gather at the home of the young man from where they set out together. Women carry the kegs of palm wine on their heads and lead the way while the men

follow them behind. On arrival, they sit at one corner of the compound where a shade has been prepared for them. The hosts sit in another corner. After the usual exchange of greetings, the men settle down for the business of the day while the women look on. The young girl to be married is called to greet their visitors. When she comes out, (she may be escorted by her friends or she comes alone) she receives palm wine in a drinking calabash cup from her father. She is expected to kneel down in front of her father to receive the cup, she then sips the drink and then rises on her feet and moves majestically around pretending to be searching for the prospective husband and when she finds him she kneels down again and gives him the cup of wine. The husband receives the drink with a great applause from all the people there; he then finishes the drink and hands over the cup and some money (cowry shells) to the girl to return to her father (in some communities the husband will accompany his wife to return the cup). This signifies that the girl has accepted the man and the ceremony can proceed. If the girl refuses to drink the wine, that signifies rejection and the people will go back home. (This is another type of rejection of a man by a girl). Now that the girl has accepted the man the ceremony can continue. The oldest man among the hosts breaks the cola nut in the traditional way. He holds the cola nut in his right hand and calls upon the ancestors to bless the young couple, give them long life, wealth, good children that will look after them in their old age, peace and happiness in their home and all the good things of life. At the end of this prayer, everybody echoes *"isee"* (Amen). The oldest man among the visitors picks up another cola nut and does the same thing. Each of them breaks his cola nut, takes a portion each, and puts the rest in a wooden plate held out by the person (people's steward) appointed to share the cola nuts. At the end of this ceremonious cola nut breaking, every other man in the assembly that has a cola nut in his hand breaks it and puts the pieces in the plate after taking his portion. (Women do not break cola nuts in the presence of men even when the ceremony is for women alone any man in the vicinity will be called to break the

cola nut). The cola nut pieces are then shared among all the people present. Wine drinking follows simultaneously with cola nut sharing.

While this is going on, selected men from both sides (about three men from each side) go behind the house to negotiate the dowry. This negotiation is done by the use of symbols. Money is not mentioned as in the open bargain for buying animals, groceries or things like that. The hosts bring short broomsticks or palm kernels and say that each piece represents a certain amount of money, let's say one thousand cowries. They count about ten pieces and hand them over to their visitors. The spokesman man for the visitors thanks them. He then confers with his group and they agree on the amount to pay. If for example they agree to pay three thousand, they count three pieces of the broomsticks and hand them over to their hosts. Their hosts make consultation again and at the end of it give them their reply. Maybe they agreed that they can take five thousand, they now count five broomsticks and hand them over to their visitors. The parties continue this negotiation until they all agree on a definite amount to be paid. The visitors then pay the amount they have at hand. This money is handed over to the witness nominated by both parties. The witness will hand over the money to the girl's father when their visitors have gone. (Dowry is not paid complete even if the people have the complete amount; that is the tradition). Sometimes in the absence of the cowries the suitor can pay with livestock if both parties agree. The young man that is getting married does not take part in dowry negotiation.

After this dowry negotiation the negotiators rejoin the others to eat their food and continue with their drinking. The titled men among them are served their food inside the house; they do not eat with others outside. After eating it is now the time for the visitors to go home. The young girl is required by tradition to go home with them "to return the keg"*(I buna ite)* used to bring the wine. She may not be the person to carry the keg, but that is how it is said. She stays for four days in her new home and returns to her parents. During this period she stays with her mother in law in her hut; not with her husband. If

her mother in law is deceased, she stays with the oldest woman in the family or any other woman appointed to take care of her during this visit. This visit is literally called "inspecting the land" *(I nene ana or I leta ala)*. After four days, she returns home with a keg of palm wine and gifts from neighbours. Her husband may or may not accompany her home. She stays with her parents until her husband comes to fetch her. This may be after two to three days. If the girl was found wanting during the visit her husband might not go to collect her. This annuls the marriage but the young man cannot get back his dowry until the girl gets married. If the girl never gets married then the young man never recovers his dowry. If her husband goes to collect her it means that he wants to continue with the marriage. When she returns with her husband this time they begin to stay together. This concludes the first part of marriage.

The second part of the marriage is a ceremony for the maidens of the girl's village to officially tell them that one of them has got married and so she is no longer with them. If this is not done, the girl must participate in any communal job or celebration by the maidens, and if she fails to show up she pays a fine as stipulated by their constitution. This ceremony involves giving these girls their food and drinks according to their constitution. Once this is done, the girl no longer joins them in their village activities.

The third stage of marriage is the initiation of the girl into womanhood. This is done in the girl's new home. All the married women in the village are invited to the man's home. They are given food, drinks and cola nuts to welcome their new member. After they have eaten and drunk, they sing and dance till dusk. This marks the initiation of the new wife into womanhood. From that day on she participates in all the activities performed by the women in the village. Failure to attend attracts fine as constitution demands.

Another big event that involves both families is *"Ima ogodo"* literally translated as "clothing the young lady". This takes place in the bride's place but it is the husband that foots the bill. For this ceremony the

man is expected among other things to bring a very big he-goat, so big that a man's clenched fist is expected to enter its nostril. He contracts music groups to perform at the in-law's place from morning till late in the night. He provides food, meat, drinks, and cola nuts enough for everybody in attendance. He buys at least six different kinds of high quality *Iyaji*, (equivalent of modern day wrappers) for his wife. On the day of the ceremony, these are displayed where everybody sees and inspects them to know if they meet the standard. When everything is ready, a date is set aside for the ceremony proper. On that day, the skin of the bride is decorated from head to toe with indigo and cam wood. The hair is styled in a gorgeous way complete with beads to look like that of a princess. She does not wear any dress except for a small piece of cloth tied round her waist to cover only as far as the buttocks and upper part of the thighs. She is expected to dance round the arena carrying a horsetail that she waves at people as an acknowledgement of their cheers. She is to dance in company of her friends for most part of the day. During the dancing, people shower her with gifts. The husband also dances with a walking stick in hand acknowledging cheers from the audience. At the end of this ceremony, the man is deemed to have completed the marriage ceremony of his wife. When they are going, the wife is presented with assorted gifts ranging from livestock to household furniture to help her start her new home. The most significant gifts are a small hen to start her poultry farm: pestle and wooden mortar for cooking: bed and bedding to start a new family: broom to tidy her place: earthenware pot for fetching and storing water, etc. These symbolic items are very important for starting a new home because they remind the new bride of her important role in the family. This ceremony is actually the equivalent of a church wedding for the present day Christians.

CHAPTER FIVE

Religious and superstitious beliefs:

The people are ancestral worshippers. They are neither atheists nor pagans as people wrongly call them. They believe in the existence of the supreme God, who created heaven and earth and all that exist on it. They believe that the ancestors are a link between the living and God. They believe that God is so awesome that mere mortals cannot talk to him directly. They can only talk to God through their ancestors who they believe are nearer to Him. These ancestors are represented in many forms in different villages and clans but they all serve the same function- to carry their supplication to the almighty God that leaves in heaven. They have different names in different places but these are mere nomenclature, they are the same and serve the same purpose. They also believe that God lives in heaven (sky) above and watches whatever everybody is doing. That He rewards the good and the wicked according to their deeds. This is why they strive always to be at peace with one another to avoid the wrath of God. This does not mean that there are no bad people among them.

Every family has its own god (*chi*). It has a shrine where the head of the family communes with the ancestors every morning before starting his day. He "feeds" the ancestors by dropping pieces of kola nut or crumbs of food or pouring libation in front of his shrine. At the

end of his communion, he sends his supplication to God by hitting his *ofor* (symbol of authority) on the ground once. The women also have their own god *(chi, ulasi, ogwugwu,* etc according to where the woman comes from. Every woman brings her own god from her original village). Only the old women are allowed by tradition to erect shrines and worship their gods openly. This is probably because the young women in the child-bearing age brackets are regarded as unclean and so not pure enough to commune with the ancestors. These gods sometimes stop their women worshippers from eating certain food items like cassava or cocoyam if they deem them unholy for their worshippers.

In addition to the personal god of every family, the kindred have a common god (*Ana*). *Ana* is simply the ground on which we stand. It is universal and no one can escape walking on the ground. It is believed that if a person does something bad and denies it, the *Ana* can strike him dead if he walks on the ground barefooted. Its shrine is located at the kindred square. There is a priest chosen by the oracle to serve (feed) this god. Upon his death the oracle chooses another person to succeed him. His symbol of authority is still the *ofor*. He uses it to send the supplication of the people to God in matters concerning the whole kindred.

There is the annual new yam festival that is performed in this shrine by the kindred before the same festival is performed at the village level. Every man in the kindred must first of all bring some tubers of yam to this shrine before he can eat his yam at home. In addition every man must come with a big cock to sacrifice to *Ana*. On that day the men roast and eat the chicken meat and yam with red palm oil in the shrine. The remaining tubers and chicken are for the chief priest *(eze muo)*. From that day, any person can go to his farm to harvest yam to feed his family. This festival comes at the end of planting season every year. As was mentioned earlier that by the time planting season is over, the yam planted around the compound is

ready for harvesting. It is this yam that was planted first that is used for this festival.

There is another god at the village level. In this village it is called *Nne nkisi*. Its shrine is situated inside the woods and a wide long road links the shrine to the village square.

This situation is not peculiar to this village it is like that in all the villages. This is to add awe and respect to these village gods. Public roads are not allowed near these shrines so that the uninitiated does not see what goes on at the shrines. Everything is kept secret to the uninitiated and this adds to the awesomeness of the gods. Consequently anything that is said that the god demands is not questioned it is believed to be true and final.

Before the new yam festival all the women of the village weed and sweep this road leading to the shrine. Most of the festivals performed

for this god take place at the village square where all the villagers gather to celebrate; only the initiated members can go to the shrine proper to offer their sacrifice. This god is also served (fed) by someone chosen by the oracle. His symbol of authority is the *Ikenga*. He uses it to intercede in the matters affecting the whole village, for example in the case of settling a dispute between the villagers. After they have given their evidence, he uses the *Ikenga* to send their 'statements' to God asking Him to deliver judgment based on the evidences provided. The villagers after that go home and await God's verdict. It is believed that within seven market weeks the guilty person encounters a serious misfortune that everybody in the village will be aware of.

There is yet another god at the town level. It serves all the villages that make up the town. In this locality it is called *Edo* and it is the representative of the clan god also known by the same name *Edo*. Its priest also uses *Ikenga* as his symbol of authority. He is also chosen by the oracle. The towns that worship this *Edo* make up the "*Anaedo*" (the land of *Edo*) clan. The new yam festival is also performed for *Edo* but it is after it has been performed in all the towns and villages of *Anaedo*.

The new yam festival for the whole of *Anaedo* clan is a big annual event in the people's calendar. This festival is to celebrate and honour the single most important crop in the land: the yam. Yam is the man's crop, it is well respected by everybody and so is the man that has a big yam barn. Yam is not only respected by the people, it is revered so much that people do not steal yam no matter where it is kept. Anybody that steals yam is taken to the shrine of *Ana* and killed. He is pinned to the ground by passing a spear through his chest. His corpse is not buried but thrown into the evil forest to be eaten by the wild animals and vultures.

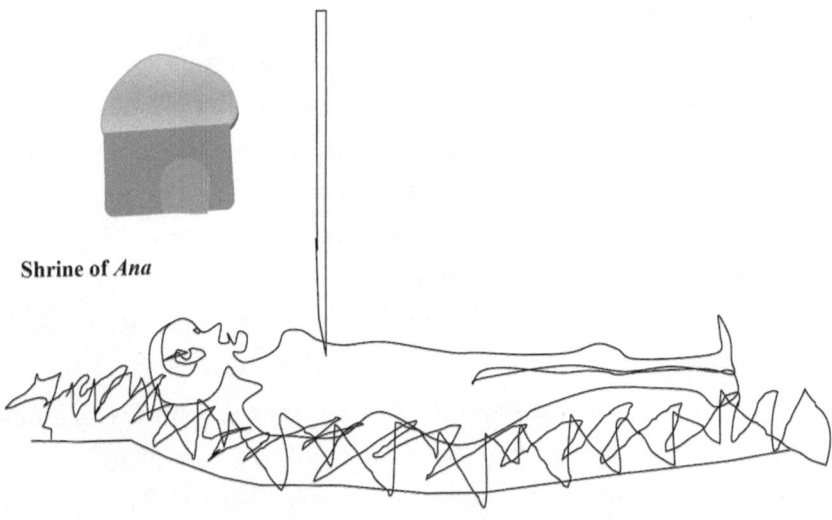

Shrine of *Ana*

The yam thief is killed by pinning him to the ground with a spear through his chest in front of the Ana goddess

The new yam festival takes many days to conclude because all the towns that make up the *Anaedo* clan come to the *Edo* shrine on different days to celebrate. Every town has got its own day and on that day all the men are expected to come to the shrine to sacrifice tubers of yam and cock. The sacrificial items are shared between the people and the chief priest of *Edo*. The people roast and eat their yam and meat before departing. After all the towns have made their sacrifices at the *Edo* shrine the following day is for the masquerades display at all the village squares in the clan. The rain makers are mandated to see to it that no rain falls on that day because masquerades do not perform in the rain or on the wet ground. This masquerades display marks the official end of the new yam festival but merrymaking continues for days or weeks thereafter. During the whole period of the festival nobody is allowed to go to the farm for any kind of farm work. All village activities are suspended including funerals. Anybody that

dies during that period is buried secretly and the funeral ceremony follows later. The period of the new yam festival is for eating and merrymaking. Any man that beats his wife during that period must use a he goat to appease the gods. The women that fight during that period must bring a white cock each to appease the gods. New yam festival is a festival of festivals and everybody looks forward to it every year.

Superstitious beliefs are rife among the villagers. It is believed that the first person one sees and speaks to in the morning determines the outcome of the person's day. For example a man going for hunting or fishing may decide to call off the trip if on the way he meets a person he knows that brings him bad luck. Sometimes a person may decide not to exchange greetings with a person that brings him bad luck if he sees him first in the morning. Sometimes a person goes to wake up another person that brings him good luck and greets him first with hope that his day will be fine. The day's outcome can also depend on which foot the person steps out of bed first. If a person steps out of bed first on his/her right foot it is believed to be a sign of good omen. If on the contrary one steps out first on one's left foot, things may not go well for the person that day. It will be one disappointment after another for the whole day.

It is believed that if a mad person gets to the market arena when the market is in session that madness can never be cured. Also if a mad person bites someone that person becomes mad.

If the foam from the mouth of an epileptic touches another person that person becomes epileptic also.

It is believed that if a pregnant woman goes to watch masquerades performance, she will give birth to a monster. For this reason pregnant women are not allowed to watch masquerades performance.

It is believed that if an "outcast" crosses over the outstretched leg of a freeborn he becomes an "outcast". For this reason children are advised not to stretch out their legs while sitting down. They must

fold their legs and sit on them or draw their legs close to their body while sitting down.

Another common superstitious belief is that if rain falls during a marriage ceremony that marriage is blessed and the outcome is bound to be favourable.

If a hunter starts catching snakes (like python) and lizards (like alligator) in his trap it is a sign of bad omen. He is advised to stop for a while before continuing. If he refuses to heed this advice his close relative will die.

If someone is going on a mission to another's place and on the way he hits the toe of his right foot against the root of a tree crossing the road the mission will be successful; the contrary is also true. This however depends on whether the person coming after the traveller in their lineage is a male or female. If it is a male the above sentence holds but if it is a female the reverse becomes true.

There are taboos also among the people, for example if a woman gives birth to a set of twins the children are regarded as evil and are killed; they are put in a basket and left in the evil forest to die. If a child erupts the upper tooth before the lower one that child is evil and so is killed. If a child is born with legs first that child is killed.

If a cock crows late in the evening when it has just entered its pen the cock has committed an abomination and must be killed and women are forbidden from eating the meat. The women however prepare the meat and bring it to the man, who eats it only with his male children in his obi. If a hen carries out its egg from the nest and breaks it, that is a taboo and the hen must be killed and eaten by the men alone. The men also eat the remaining eggs; women are not allowed by tradition to eat eggs. It is believed that they will become gluttons if they eat eggs.

If a goat touches the egg of a hen with its snout, that is forbidden and the goat must be killed and eaten by the men. Women and girls do not eat the meat of any animal that has done what is forbidden.

The community also frowns at certain demeanours like incest or a man sleeping with his father's wife. Such a man is treated the same way as a rapist, *vide infra,* or even stoned to death and his body thrown into the evil forest. The woman concerned undergoes a ritual cleansing because she is regarded as a victim and so is not killed. If a man is caught having sex with an animal he is stoned to death or buried alive.

CHAPTER SIX

Health care delivery services:

There are no health institutions of any type. Traditional healers offer health services. In other words only roots and herbs are dispensed. Traditional healers hand over their skill to their children or some other people who chose to practise that art. There are some other people who do not undergo this tutelage; they just wake up and start the art of healing claiming that the gods have chosen them to do so.

A sick person is taken to the traditional healer for treatment. The treatment may be in the form of drinking concoction obtained from boiled leaves or using the concoction to bathe. Another form of treatment involves the use of charms to drive away evil spirits. This charm is placed in the bed of the sick person or on top of the door leading into the hut or at any other chosen place. Sometimes animal sacrifices may be performed to appease the gods. There is another form of sacrifice that does not use animals; it involves collecting things that resemble the modern day biscuits, sweets, soft drinks and the likes, putting them in a basket and taking the basket to a road junction at night. This is done if it is suspected that the child is a changeling. According to the seers the child joined the changeling cult unknowingly before his or her birth. It is believed that once the members "eat" this sacrifice they leave the sufferer alone. If it is

suspected that witches are disturbing a person, he or she is advised to put cocoyam in his or her bedroom. It is believed that the presence of cocoyam in the room prevents the witches from coming back to disturb the person at night. Sometimes the person that is disturbed by the witches is advised to put a basin full of water in the room. It is claimed that if the witch sees her reflection in the water she must die.

Steaming is another form of treatment especially if the person is suspected of having malaria fever. The healer would collect different types of leaves, roots and bark of trees and boil them together for a long period. When they are well cooked and the water very hot, he removes the pot from fire and places it on the ground. The sick person sits on a stool near the pot and bends his head over the steaming pot. The healer wraps him over the pot with a big mat so that the steam is concentrated on his body. The mat is removed after about ten minutes. By that time the sick person is dripping with sweat. He gets well after sometime most likely the same day.

Traditional birth attendants conduct child deliveries. These traditional birth attendants do not receive any formal training. They learn their art from their predecessors who could be a parent or a neighbour. There are no antenatal services during pregnancy. When a pregnant woman is due for delivery, some women escort her to the house of a birth attendant. The birth attendant monitors her until the child is delivered. The child is delivered on banana leaves spread on the ground behind the hut. The newborn baby is taken into the house after he or she has cried. The child that does not cry is left outside until he or she cries or dies. If there are complications the woman or her child might die or both of them might die. There are no referral centres because even the neighbouring villages use birth attendants also. The woman that has just given birth to a baby does not eat whatever other members of the family eat. She eats yam porridge that is heavily spiced and without palm oil and drinks warm water. She eats this type of food for at least seven market weeks. Her mother cooks her food but if her mother is deceased, her mother in law cooks for her but if she

is deceased also a woman from the family cooks for her. Her mother foments her lower abdomen daily; this helps the abdominal muscles and the uterus to involute (recover) fast. Her mother takes care of her and her baby until she is fit to take care of herself.

The mother then returns home. When going home her in-laws are required by tradition to give her a lot of gifts like foodstuff, salt, dry pepper, clothing materials and wearing apparels, tobacco snuff etc. when she gets home she shares some of those items with her neighbours at home to show that she has returned from taking care of her daughter that has just given birth (*ine omugwo*). Her son-in-law also gives her something like dry gin *(kai kai or ogogoro)* for her husband. He drinks this with his neighbours to celebrate the arrival of his wife and safe child delivery of his daughter. They must not forget to thank their ancestors before their celebration so he must first of all pour libation in front of his shrine before they start drinking.

The father, grandfather, and grandmother of the newborn baby give the child a name each. They give these names in front of the family shrine. Naming ceremony is not a big occasion in this community. That not withstanding they must sacrifice a he goat to their ancestors before pronouncing the names. The family members share the goat meat at the end of this short but important ceremony. The meat is used to cook food that everybody eats to rejoice for the arrival of a new member to the family.

CHAPTER SEVEN

Growing up in the village:

Raising a child is primarily the job of his or her parents but every adult in the community contributes in one way or another. "It is said that anybody that hears the cry of a baby must hurry to attend to that baby because the child belongs to everybody". So with that spirit everybody takes care of a child. If a child is in a neighbour's house when food is cooked, that child must be given food to eat. If a woman sends away a child when food is ready without giving that child food, she could be reported to the women organization and she might be reprimanded. Likewise if a neighbour sees a child misbehaving she must reprimand that child; she can even flog the child if the misconduct is a serious one. People frown at children receiving gifts with their left hand from adults, so if a child tries to receive something with left hand from an adult, that adult reprimands the child immediately without reporting to the child's parents first.

A child who is naturally left-handed is forced by his parents to change to the use of right hand. This shows how vehemently people abhor the use of left hand; they even equate the left hand to anus something very dirty and unclean.

Children in the community do a lot of things together; they play, fetch water from the streams, fetch firewood from the bush, go fishing,

hunting, gathering fodder for animals always in groups. When a woman asks her child to fetch water, the child picks up his or her calabash or clay pot and goes from house to house looking for friends to accompany him or her. If a child wants to fetch firewood he gathers all his friends and they go together. When a child finishes what his mother asked him to do, he looks for his friends to go and play together in the sand. They may play "hide and seek" game or "cook and eat" sand or build "houses" with sand and childish things like that.

When they get older they work together in their farms in rotation. The days they are not working they go fishing in the streams. They use baskets to catch small fishes. They put the basket on its side in the river very close to the riverbank, one of them holds down the basket while others attempt to startle the fish from their hiding places. He raises the basket from time to time to see if any fish has been caught. Any fish caught is put in a calabash container specifically designed for that. This calabash has a wide aperture on its top and a rope that serves as the handle attached on either side of the aperture. They may fish for a long time without catching any fish because this is not an effective way of fishing. They may decide to dig crabs along the riverbank. Some days they go home with nothing; no fish no crabs.

Sometimes they go hunting for rats in the bush. When they find a rat hole they try to locate the emergency exit of the rat and close it with grass or leaves before digging from the main entrance of the hole. When the rat tries to escape they club it to death but sometimes the animal gets lucky and escapes. They may decide to set a bush ablaze, stand along the roads surrounding the bush to pursue and club to death any animal that runs out. After burning the bush they enter the burnt bush to dig out rats that have suffocated in their holes. They can also use their catapult to shoot birds, squirrels or even lizards.

When growing up, children are taught to respect and help elders at all times. Whenever a child sees an older person he must greet him or her. Any child that doesn't greet elders is punished or reprimanded openly so that he can change. It is the duty of the children to fetch

water and firewood for old people who don't have helpers. If a grown up child sees an old person carrying a big load he is obliged to take that load from the old person and transport it to the required destination. The old people in turn bless these children and give them gifts always.

The children do not wear any clothes; they go about naked both boys and girls. They remain like that until puberty when boys start to tie loincloth and girls wear beads round their waist. There are no shirts; a man lives his whole life without putting on a shirt. During special occasions he can tie a piece of cloth over his body. The piece of cloth is wound from under the right armpit and tied above the left shoulder. It hangs down as far as the buttocks or thighs. Women decorate their skin with indigo and cam wood; they don't wear blouses and only older ones wear skates. Brassieres are not in existence. Women tie piece of cloth to cover and support their breasts during special occasions or dancing. This cloth is placed over the breasts and tied at the back.

CHAPTER EIGHT

Initiation into the prestigious nze na ozo society (ichi ozo):

This is a very prestigious event that every man in the community looks forward to. It is conferred only on respected men in the community. (An "outcast" is not allowed to take a title no matter how rich he might be so also is a notorious criminal barred). The title elevates the status of the conferee in the community and beyond. The title confers on the conferee not only honour and respect but also some responsibility and restrictions.

A titled man wears a red cap with eagle's feather on it to distinguish him from the red cap of non-titled men. He is addressed as "chief" in any public gathering. He chooses a new name that has a prefix-*"eze"* attached to it. He greets people with his leather fan no more his bare hands. He greets his fellow titled men in a specific way reserved for them, and the others he greets with only a wave of his fan. He sits only on a carved round wooden stool that has its top and bottom looking alike *(oche mpata)*. An aide carries this seat for him anywhere he goes and when he is seated the aide stands behind him. He carries an elephant tusk that he blows to greet his fellow title-holders when he passes by their house and the other responds from within. A title-holder does not eat in the open (public places); if he goes for an

occasion in which he must eat, he is served inside a room. No outsider must see the mouth of a chief while he is eating.

From the day of his coronation he is expected to behave in a dignified manner so as not to drag the institution of title-holders into disrepute. He denounces all other associations and belongs to the association of title-holders only. He no longer indulges himself in the activities of the young people. He must no tell lies or give false evidence in any dispute whether it is for or against him; if he does he dies or goes mad. He must not seduce another person's wife or daughter.

The preparation for the taking of the title takes years to complete because it involves a lot of money and materials and also a lot of ritual cleansing and purification to make the man fit both in the eyes of men and gods for the honour he is to receive. The person intending to be initiated into this prestigious cult first consults the oracle to know the type of title he is to take. There are different types of *ozo* titles, which only the initiated know the differences. The ordinary man in the community only recognizes that some wear white thread around their ankles while others don't. When this has been ascertained he prepares himself according to the dictates of the society that he intends to join. The details of this preparation are beyond the scope of this write up because only the initiated members know what happens there.

The intending member must be married to at least one wife; many wives are preferred. Culture and tradition forbid an unmarried man or a widower from taking *ozo* title. The unmarried man must get married first and a widower must remarry. A titled man must not be seen cooking his food in the kitchen and he does not eat food prepared by children so he must have a wife. He must not seduce another man's wife or daughter so he must have his own wife to avoid temptation if he must live up to expectation. He must also erect a wall round his compound; this wall is decorated with paintings before the coronation. These paintings mark out the compound of a titled man in the community from those of the uninitiated.

Next he starts to improve his looks; he applies cam wood juice on his body to freshen his skin for the occasion. He eats nourishing foods because he is expected to look healthy and fresh during the coronation ceremony. He starts to learn how to comport himself in the public in anticipation to his new status; he curbs his excesses, moves, talks and generally behaves in a dignified manner.

When he has got everything needed for the coronation he invites the members of the society that he is to join and a convenient date is chosen for the ceremony to start; the whole ceremony takes about ten days to complete. This ceremony is usually performed in the dry season so that rain doesn't disrupt the function. About two weeks to the D-day young men women and children start to prepare the man's compound for the big occasion. The women polish the compound wall with red semi-solid mud and decorate it with paintings of various types of animals (cow, goat, sheep, dog, cat, horse etc) and implements like hoe, spear, matchet, etc. The young men go into big forests to cut firewood while the children clean all the roads leading to the compound. The whole community is now in a festive mood.

He must invite all the title-holders in the community and beyond, all the dancing groups and masquerade groups, all his relatives far and near, all his former clubs members and all his friends that are not part of the preparation. The invitation is not by mere words of mouth; he must invite each group to his house and give them food and drinks to inform them of his forthcoming coronation. Any invitee must attend the coronation with something substantial as a present to the chief celebrant. He must also engage the traditional drummers (*ndi ekwe na uvie*) and flutists (*ndi oja*) to perform from the beginning to the end of the ceremony. In fact these men start to perform in his compound about four days to the D-day. They sing the praises of the man to be initiated and use their instrument to call his chosen new names. They receive cash payment and are entertained lavishly throughout the period of the coronation.

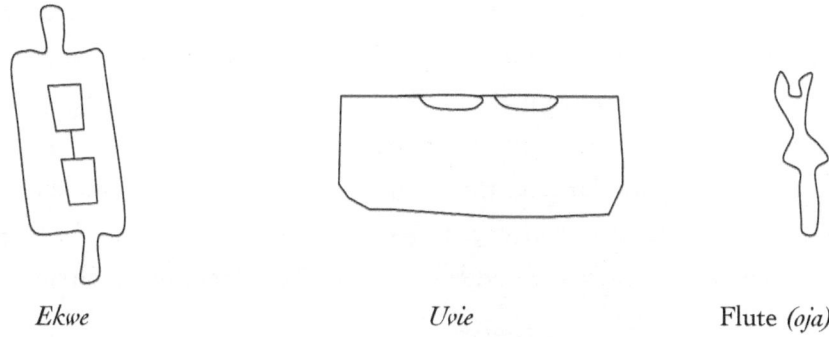

Ekwe Uvie Flute *(oja)*

All the three are hollow wooden traditional musical instruments.

The celebrant is not seen in the public for some three to four days before the ceremony. It is assumed that he communes with his ancestors during that period. He asks them for protection against evil men. He also engages powerful medicine men to prepare potent charms for him to counter the charms of detractors. He also meets the leaders of his intended society to be initiated behind closed doors. There they teach him their rules, which he must not deviate from. They teach him their dos and don'ts and he swears to the oath of allegiance to the society. This is the real initiation; the one that follows is only a celebration to entertain his people.

On the day preceding the D-day cows are slaughtered and the meat shared according to the tradition and culture. Specific portions are reserved for some specific people; the women use the rest to cook food to be served on the first day of the ceremony. The dry skulls of these cows adorn the obi of a titled man. They are hung on the rafters of the building where everybody that enters the obi sees them. Their number speaks volumes of the wealth of the man in question. On that first day of the ceremony all the wine tappers bring their wine home for the occasion; none is to be sold to outsiders that normally come to buy it.

On the first day of the ceremony the man emerges in the public late in the morning (around eleven o'clock). His skin is smeared with cam wood from head to toe. He ties a small piece of cloth on top of his loincloth; he wears a red cap on his head. Flanked by titled men of his society they all dance to the traditional music being played. They dance for a while and converge in front of his personal god *(chi)*. He sits down on the carved wooden stool *(mpata)* in front of the shrine.

mpata

The society leader puts white eagle feathers on his red cap and blesses him. He winds a wrapper from under his right armpit and ties it over his left shoulder; this covers him down to his knees. The leader also hands him over his elephant tusk. If it is the society that ties white thread around the ankle, he ties the thread around his ankle. At the end of this traditional ritual they escort the celebrant back to his seat in the shed prepared at one corner inside the compound. This shed is lavishly decorated with assorted types of clothing materials and animal skins. Two of his sons carrying carved alligators in their hands stand on either side of his stool.

Throughout this period traditional music is continuing and merrymaking going on uninterrupted. As he is seated invitees start to come forward with their presents. The stewards take anybody that offers

him a gift to a corner to be entertained. If a titled man comes forward to pay his respect the drummers eulogize him and call his title name with their instrument (*ekwe*). These titled men are entertained inside the house not at the corner like the other people, *vide supra*. Drumming and dancing from various groups continue till dusk when the celebrant retires.

The ceremony continues like this for four days or to the next *nkwo* market day when the ceremony shifts to the market arena. A lot of people escort the celebrant and his wives as they dance majestically round the market acknowledging cheers and receiving gifts. At the end of this parade they retire to one corner of the market. The drummers and flutists continue to eulogize him even in this market. The ceremony continues till evening when the drummers and the crowd escort the celebrant home. This marks the official end of the coronation but it does not stop people from being entertained in his house for days to come.

Some titled men tattoo their faces but this is optional. (This is called *Igbu ichi*) Tattooing disfigures the face and leaves curved grooves on the face making some people look scary. Again tattooing is painful; sharp knife or blade is used to cut through the skin and dye (pigment) instilled to make the mark permanent; this is done without anaesthesia. After the tattooing, the person sits near the fire and bends his face over the fire to dry up the exudates and this takes many days or weeks. During this period also the person eats heavily spiced food 'to prevent wound infection'. Traditional tattooing actually tests a man's ability to endure pain to its limits. These are some of the reasons why some people opt out since it is not a prerequisite for title taking. There is however a superstition surrounding the actual process of *igbu ichi*. It is widely believed that before this process starts, that the traditional priest that performs this art will transform this person into an animal like a monkey and so he will not feel the pain of the cutting. Consequently hunting is prohibited throughout the period of *igbu ichi* and the recovery so that the man will not be killed since nobody knows exactly which animal he is transformed into.

CHAPTER NINE

Funeral ceremony:

In the event of the death of an adult male, preparation for the burial starts the very day the incident occurs till the day of the actual ceremony. Immediately the man expires his family members near and far are notified. All the in-laws (those marrying his daughters and his sisters, and those that his sons marry their daughters) are invited. During this meeting the death is officially announced to them. The day of the burial ceremony is also chosen after due consultation with all the parties concerned. The people then go home to prepare for the D-day.

A few days before the funeral ceremony, selected young men from the village go from house to house to inform every household of the passing on of one of their illustrious sons. On the eve of the ceremony the villagers gather in the home of the deceased. The women fetch water, cook food, clean the compound and make sure that everything is in place. The men clear the surrounding bushes to create enough space for the invitees to exhibit their dances and masquerades the following day. In the night the members of the deceased's masquerade group take centre stage. They play and dance for the whole night. They climb and break down the fronds of all the palm trees in the vicinity. They tie palm leaves around all important fruit trees in the vicinity to prevent them from being destroyed during the ceremony.

Everybody knows that any tree with palm leaves around its trunk must not be touched during the ceremony.

On the day of the funeral, the deceased lies in state in the bed prepared in the centre of the sitting room of the main family house or in his obi especially if the obi is within the compound and not outside. If the deceased is a young man who died suddenly, he is seated upright on a chair with his spear in his right hand. The man's widow or widows sit(s) on a mat spread on the floor at one corner of the same sitting room. Her close friends her young daughters if any, and some other close female relatives usually surround her to give her some moral support and encouragement.

All the adult villagers are expected to assemble in the man's compound in the morning from around six o'clock. Everybody on arrival is expected to go inside the house to pay his or her last respect to the deceased. Thereafter the women remain within the compound while the men gather outside. Anybody that wishes to sit down comes with their own chairs because only a few chairs are usually provided; a few chairs borrowed from the neighbours as there were no chairs for hire or rent. Some of the young men climb the palm trees and cut down the fronds that they use to provide a temporary shed for elders and the male chief mourners just outside the main entrance to the compound. The remaining young men dig the grave at the site provided by the family. Meanwhile the traditional music group contracted to play the wooden gong (*ekwe*) and the associated instruments select their site, set up their equipment and start their job. They are there for the whole day playing their instruments. They use the wooden gong to call the name of the deceased. This is done so well that people from nearby villages could decipher the name of the deceased just from the sound of the *ekwe* and the direction it comes from without any prior information about the death of such a person. At the end of this morning gathering the villagers go home for their breakfast. The wine tappers go to the riverbank to tap and bring home palm wine that will be used to

entertain the guests in the afternoon. At this time practically only the close relatives are left in the compound.

The villagers gather again after their breakfast to continue with the ceremony. There is no fine to be paid for not coming for the funeral of a village member. The only punishment for anyone who absents himself from funeral ceremony is that people will not go to his house if he is bereaved. The fear of being abandoned in one's hour of need makes everybody attend funerals. When people come back from their breakfast they remain there doing different things; some are dancing to the music that is being provided by those contracted to play music or to the music of the masquerade groups preparing for the afternoon while some gather in groups talking among themselves. All these forms of activities continue until the deceased is buried in the late morning or early afternoon. Corpses are buried without coffins, they are simply wrapped in a shroud and put in a cane basket prepared for that purpose and then buried with it. A titled man is buried at night by only his fellow titled men. So in the afternoon the body of a titled man is removed from the sitting room and put in his room until nightfall.

After the interment or removal of the body from the sitting room in the case of a titled man the actual ceremony begins. The male chief mourners, i.e. his sons and his brothers stay in the prepared shed. They keep a big basin on a table in front of the shed so that anybody that wants to offer them any condolence gift puts it in the basin. The in-laws and other invited guests now begin to come forward to be recognized and acknowledged. Every in-law is expected to come forward accompanied by a group or groups of dancers and masquerades to pay his condolences (or see his in-laws as it is called). The first son in-law, that is, the man that is marrying the first daughter of the deceased is expected to present a live cow, two metres of cloth, and a lot of assorted drinks both alcoholic and non alcoholic. His group performs its dances and thereafter the group members are entertained in a neighbour's house or any other place of their choice. They are given enough to eat and drink no matter the strength of his

contingent. All the other in-laws are not obliged to present cow but anyone who is capable can present a cow and it will be thankfully accepted. Each group is entertained at the end of its performance. All the groups, both the invited and the uninvited that perform in that ceremony must be entertained at the end of their performance.

There is usually firing of the cannons during the funeral ceremony of a man. The number fired depends on the capability of the chief mourners. These cannons are usually lined up along the main road leading to the compound of the deceased. They are fired in the morning, afternoon and night.

The deceased's daughters have to go about carrying in their hands fan made from leather or raffia singing the praises of their late father. The first daughter carries a horsetail instead. This distinguishes her from her younger sisters. They do this individually not collectively and they are usually accompanied by their friends. The people that come to the ceremony are expected to give them money and other gifts, which the accompanying friend usually collects and keeps till the end of the ceremony when she accounts to her.

The people from the deceased's maternal home have to run round his compound, cut down a tree and bring it to the arena where the function is taking place and leave it there. Just immediately it is dropped the villagers will remove it showing that they were waiting for it to happen. The ceremony comes to a close at dusk when the chief mourners vacate the shed.

The hair of the deceased's widow is shaved off the morning after the funeral. The person to shave her hair or at least start the shaving must be a woman from the husband's kindred and not a married woman from other kindred. The widow or widows are expected by tradition to mourn their husband for a period of at least one year. During that period the woman is not expected to attend any public gathering; she should not go to the market, she should not fetch water from the stream or fetch firewood from the bush, she should not attend funeral ceremonies or even village meetings. Her children have to do

everything for her but if she doesn't have children or people to help her she does all her chores at night or very early in the mornings when only a few eyes will see her. In such special cases the period of mourning is reduced to six months and certain restrictions are waived to enable the woman to cope. When the period of mourning is over the woman is escorted to the market by the village women and that marks the official end to the mourning. She can then join the community in doing whatever they are doing.

Traditionally the woman will not be left without a husband; she has to choose one of the husbands brothers as her husband. Usually it is the husband's immediate younger brother but the woman has the right to choose any one she prefers. When she has made her choice the villagers are notified formally with kola nuts and kegs of palm wine. After that she can decide to have children with her new husband if she is still young and they need more children. In a polygamous set up the process is a bit different. The younger brother of the deceased might decide to take care of his late brother's wives and in that case the ceremony of formal remarriage of the women is performed. In another instance the first sons of the women concerned (if they all have sons) will swap their mothers as wives, that is the son of woman A becomes the husband of the woman B and the son of the woman B becomes the husband of the woman A. If there are more than two women involved the swapping is arranged in such a way that no woman is left without an official husband no matter how young the child might be. If a boy is too young to father a child and his wife needs more children she can go ahead and have one in the name of her new husband. The children born in that way are traditionally recognized as the boy's children and they have to partake in the sharing of his property when the time comes.

The funeral ceremony of an adult woman is different in many ways. There are no masquerades because women are not members of the masquerade cult. The wooden gong (*ekwe*) is not sounded during the funeral. Cannons may be fired during the ceremony but it is not

mandatory. Her maternal relatives do not cut down a tree during her funeral. The husband of the deceased does not sit near the corpse inside the house; he sits outside in the temporary shed provided. He does not shave his hair.

Women are buried in their fathers' homes but very old ones that have male children are buried at their husband's homes. Some of these women are buried according to the tradition of their kindred or village of origin. Some of them are seated upright in a complex tunnel that does not resemble a grave. This type of burial is called *'ina nsukwu'* and it is not widely practiced; only a few kindred practice it and prospective suitors generally avoid marrying their daughters because of intricate rituals involved.

In the case where a young woman dies, her husband's people have to carry her corpse in a wooden coffin or long cane basket made for that purpose, on their head halfway through and hand over to her people. If the deceased was a good woman that was liked by everybody, they would carry her body to her father's compound as a mark of their love for her. Apart from the above mentioned exceptions women funeral ceremony follows the same course as that of the man.

The course that a child's funeral takes depends on the age of the child. If the child was more than one year old, every family in the village must be notified about the death and everybody must come for the burial but elaborate preparations are not made like in the case of an adult. The funeral ceremony lasts up until the child is buried and everybody disperses. If the child was less than one year old only close relatives are informed and they come and bury the child and disperse.

What happens to the property of a deceased man depends on a number of factors. If the man had a grown up male child then he inherits everything his father left behind but if the deceased had many male children, the first male child inherits everything that his father left behind. All the other male children of the deceased man get nothing. Every one of them must apply to the community to give him a piece of land from the communal land to build his house and start

his new home whenever he becomes of age. The girls both married and single do not inherit anything that their father owned. This first son collects dowry whenever any of the single girls gets married. He is officially their father irrespective of his age in relation to the girls' ages.

A reasonable young man doesn't apply the rules of the tradition to the letter. He could decide how he wishes to share his father's property with his brothers irrespective of what tradition stipulates. The tradition clearly is biased towards the first son and leaves every other person empty-handed and disappointed. He does not drive away all his brothers from the compound; anyone that wishes to build his house within the compound is allowed to do so provided there is enough space to accommodate him. Every member of the family is still accorded his or her due respect irrespective of the tradition; the girls for example are still treated as humans not as property of the first son. They however must get married and leave because no woman is allowed by tradition to build her house in her father's compound no matter the good relationship existing between family members. Sometimes this kind of consideration by the first son stems from the relationship that was existing in the family before their father's demise. Where there was peace in the family before the man's death some people would want to maintain the good relationship.

However in the family where there was bitterness and rancour when the man was alive, after his death his first son is forced to apply the rules of tradition to the letter. He might be doing that out of fear that his stepbrothers might want to kill him out of jealousy so he decides to keep them at arm's length for the sake of his safety. He insists that every one of them must leave their father's compound for him. He might be driven by vengeance to settle old scores now that his father is no more. Some may be oppressive out of mere greed for power, to show them that he is in control and can do and undo. Many people do wicked things for different reasons but the end result is

always disaster. Nobody stands to gain from such acts no matter what tradition stipulates.

In a situation where a man dies without a male issue his brother takes everything he left behind and manages them as he likes. If the deceased man has many brothers the eldest surviving brother (not stepbrother) takes everything he left behind but if the deceased doesn't have a brother the eldest surviving stepbrother takes over. Girls do not inherit their father's property and wives do not inherit their husband's property because they are property themselves; men must inherit them. Such is the fate of a man without a male child, little wonder then that men can stop at nothing to get a male child. A man whose wives fail to give him a male child continues to marry new wives until he gets a male child or dies trying.

CHAPTER TEN

People's Pastimes:

The community engages in a lot of activities during the dry season when farm work is completed. These include dances for men, women and children and masquerades for adult men only. Every year each age grade, society, meeting or organization practises a new dance to be exhibited at the end of the year. These dances are mainly imported from the surrounding towns and villages.

Every group that decides to import a new dance or masquerade sends three to five members of the group to tour the neighbouring towns and pick up a dance to be learnt. The dance in most cases must be new to their community. These emissaries go to the places earmarked and watch the dances penciled down for importation. As they arrive the dancers are called to perform a demonstration dance for the visitors. If they are satisfied the group is invited to come and teach them the dance. If they are not satisfied they return and report that they should look for another one. The search continues until a suitable one is found.

The chosen dancers come and perform at the village square in front of a large audience. At the end of this display they retire to the place where the dance is to be taught. It could be the home of the group leader or any convenient place chosen by the group. The place is

usually a walled compound to exclude spectators during the practices. Each member of the group chooses a friend from the visiting group. He/she takes the friend home and stays with him/her for the duration of the learning process. He is responsible for this person's welfare during this period; it is not the responsibility of the group. The visitors teach the group their dancing steps for about two market weeks (about eight days). During this period practice is every morning and evening. At the end of this period they return home leaving the group to practise on their own. The practices continue in the evenings until everybody masters the dance steps. When they think that they have mastered the dance steps, they invite their teachers to watch their performance and rate them. If the visitors agree that they have perfected the dance they give their approval. The date for the public exhibition of the dance is chosen and the visitors return to their village. On the day of the exhibition the two groups entertain the spectators in what looks like a contest. After that day the teachers go home as their work is completed. The dance can then perform in any ceremony if they are invited; before the public exhibition of a dance it cannot be performed in the open. The importation of any new dance or masquerade follows the same procedure.

Only the initiated adult males perform the masquerade dance. Initiation is done in the house of a person where the head masquerade *(isi manwu)* stays. This is the most revered and most powerful masquerade in the community and he alone initiates new members into the masquerade cult. Initiation is done at night usually during the full moon. Each intending member brings cola nuts (seven or eight) and palm wine to present to the initiated members to announce his intention. His father or uncle is expected to accompany him on this visit that is made only on the day the cult members meet for their monthly deliberations. They would accept an intending member's present and then ask him to wait for a message from them. When they have received presents from a reasonable number of intending initiates they invite them for the initiation.

On the day of the initiation all the intending members bring twenty litres of palm wine each. The members drum and dance and drink while the boys gripped by fear camp at one corner of the compound. When they are done the "head" masquerade emerges and reveals all the secrets and myths about the masquerades to the boys and makes them swear to an oath of secrecy and allegiance. Story has it that this 'head' masquerade emerges from the ground through an ant hole at the peak of drumming and dancing by the members. The boys are initiated and can then join the masquerade group of their choice.

Another pastime in the village is playing at the village square at night during full moon *(egwu onwa)* literally meaning dancing in the moon. On a particular day of the market week young people gather in the village square to sing and dance and entertain themselves. Some older women join them but they sit by the sideline and watch the young people enjoy themselves. This happens once every eight days if moon is shining. The singing and dancing continue late into the early hours of the following day; they disperse when they are completely exhausted. While women and children are in the village square the men gather themselves in the house of one of them to enjoy the night. This social gathering is called *nkwu mgba*. During this gathering they play and dance the masquerade music without the masquerade appearing physically. The host provides enough palm wine for everybody in attendance. Some women especially the elderly ones sometimes join them. It also lasts till the early hours of the following morning like the *egwu onwa*.

A lot of festivals to celebrate various events take place in the dry season. They include *'afia olu'* to celebrate the end of planting season and to thank the gods for guiding them during this period. *'Iku izu'* is another festival to herald the dry (resting) season. *'Ilomuo'* is a festival to thank the ancestors for keeping watch over them all the time. These festivals keep the villagers entertained and also relieve boredom associated with the dry season. They also promote nutrition indirectly because some families eat meat and good food only during these festivals.

Afia olu is celebrated to mark the end of planting season. During this festival everybody invites all the other people that helped them in their farm work throughout the planting period. They cook very delicious meals to entertain these invitees. They give their visitors gifts when they are ready to go home at the end of their visit. The gifts are in the form of foodstuff, livestock, clothes or anything the host can lay hands on. The people that are not invited or those that do not invite others occupy their time at the village square watching masquerades and dances. The villagers slaughter a lot of domestic animals like goat, sheep, chicken etc during this festival. This festival takes two days officially but nothing stops anybody that wants to extend his merrymaking from doing so.

Iku izu is just a festival to celebrate the fair weather; it does not have much significance. It is synonymous with eating dog meat; a lot of dogs are slaughtered on this festival. Dog meat is usually not used to cook meals probably because it is very fatty; it is cooked and eaten with palm wine. People usually invite their friends to celebrate with them. Masquerades and dances perform at the village square as in the case of *afia olu* mentioned above. The festival takes only one day.

Ilomuo is a festival to honour the ancestors. During this festival every adult male must kill at least a big cock in his shrine; he sprinkles its blood on the altar and prunes the feathers and scatters them along the main entrance to his home. He uses this period to mend anything that has damaged in his shrine, for example the damaged dolls in the shrine or the shelter of the shrine will be replaced. Every old woman also kills a cock in her shrine but she does not scatter the feathers along the road; she only heaps the feathers on her shrine. Every married young woman must cook *foo foo* and delicious soup stuffed with dry fish and present it to her father or her eldest brother (if her father is deceased) to be used as sacrifice to the gods. On her arrival at her father's compound she takes the food straight to the shrine where her father 'feeds' their ancestors by dropping some *foo foo* balls in front of the shrine. He also pours libation from the wine brought by the

woman's husband. The family members and neighbours gather to eat the remaining food and thank their daughter for the delicious meal. They also drink the palm wine her husband brings. After food the daughter is expected to visit their neighbours and every neighbour is obliged to give her tubers of yam or plantain or anything else for those that don't have yam tubers or plantain. Masquerades are not allowed during this festival so that they do not disturb the daughters visiting their fathers. As was mentioned earlier, women are not initiated into the masquerade cults and so are afraid of the masquerades.

Some men in the community have local tambourine *(ubo akwara)* made from calabash and flat pieces of metal. The calabash is cut into two symmetrical halves and a flat rectangular piece of wood is fashioned to fit into the open side of this calabash leaving spaces on either side. (The player puts his hands in these spaces to hold and play the instrument). Five to eight narrow pieces of metal of unequal lengths are fixed to this rectangular piece of wood in such a way that the unequal ends of the metal pieces stick up a couple of centimetres above the surface of the wood. The wood with the metal pieces on it is fixed to the open side of the calabash to form a bowl-like musical instrument. When the free ends of these metal pieces are tapped with the tip of fingers, music is produced and villagers usually gather at the house of the owner to be entertained especially during full moon.

A type of Tambourine *(ubo akwara)*

CHAPTER ELEVEN

Conflict resolution:

The chief is the custodian of peace in the community. The elders assist him in the discharge of this responsibility. Family conflicts e.g. quarrels between husband and wife are resolved by the family elders. The aggrieved person reports to the elders formally with some cola nuts and a calabash of palm wine. The elders set a date for the hearing and send a messenger to go and inform the defendants about the case against them. On the day of the hearing both parties come with eight cola nuts and a big calabash (at least twenty litres) of palm wine each. The complainant states his case and the defendant responds by stating their own side of the story; lawyers are not used. Before stating their case the person removes any shoes on their feet if any and stands on bare ground to give evidence. This is done in the belief that anybody standing on the ground, which is worshiped by the people as their god, and gives false evidence, will receive a serious punishment from the gods. So this deters people from giving false evidences. They can call witnesses if they have any to corroborate their stories. The elders then consider their submissions and those of the witnesses and give their judgment. The guilty person apologizes to the other person or pays fines in kinds (like cock) not cash as may be decided by the elders. If

any person is not satisfied with the verdict, he/she can appeal to the chief.

More serious crimes like stealing, rape, adultery, murder etc are reported directly to the chief. The aggrieved person(s) lodges formal complaint at the chief's court with cola nuts and palm wine. The chief confers with community elders and sets a date for the hearing. He sends a messenger to inform the accused of a case against them. On the day of the plenary hearing the complainant and the defendant bring eight cola nuts and big calabash of palm wine each as in the case of a lesser offence mentioned above. The hearing follows the same procedure; the plaintiff states his case and calls his witnesses if any and the defendant does the same. The chief and the elders consider the evidences given by the plaintiff and the defendant and give their judgment. In the case of stealing if the evidence against the accused is not well substantiated a soothsayer may be consulted to identify the thief. The punishment for serious crimes ranges from ostracism to death. A person that steals yam is taken to the community shrine and killed by pinning him to the ground with a spear through his chest. The corpse of such a person is not buried but thrown into the evil forest to be eaten by wild animals and vultures. A person that steals livestock, household items etc or an adulterer is ostracized for a specified period of time. At the expiration of this period he is reunited with the people after a cleansing right has been performed but if he commits the same offence again or any other serious crime he is banished from the community for life. If a person is convicted of murdering another person a long nail is driven into his head and allowed to die. The community does not mourn the death of such a person; but his relatives are allowed to bury his body without any funeral rights. A rapist is banished from the community for life or may be sold to another community that needs someone to sacrifice to their idol. This person is not killed rather he is kept alive but as a property of the idol. The community performs a ritual to dedicate him to the idol; the climax of this ritual is to give the man white chalk

(*nzu*) from the shrine of the idol and he shall eat it. Once he eats this white chalk he is married to the idol and he remains the property of this idol and no freeborn child of the clan has anything to do with him. He lives near the shrine and is used to assuage the gods when anybody commits a minor offence that requires assuagement. He is brought to the shrine and is tied to a rope and dragged on the ground in front of the shrine to appease the gods. After this he goes back to his hut and waits for another such occasion. The community uses him to perform other cleansing rights or dirty jobs e g when someone hangs himself, an act regarded as an abomination, he is called to go and bury that person. He brings down the body of the person from his hanging post and buries it in the evil forest; however he does it is his own business because tradition forbids any freeborn from helping him to do it. He does not socialize with other members of the community; he can socialize only with his kind from other communities. He visits his neighbours only for business. He goes there and does whatever he goes there to do and leaves. The descendants of these people are the 'outcasts' and that is why nobody in the community wants to associate with them in any form knowing their history. These outcasts still leave around these shrines till date. So in this community where one lives tells a lot about the person; if one lives near a shrine or his ancestors lived near the shrines people know that that person is an outcast.

A land dispute between neighbours is reported to the chief and resolution follows the same process outlined above. The chief and the elders delineate the new boundary and anybody that infringes on it again is deprived ownership of the disputed portion of land.

If a cash crop is the bone of contention the chief may decide that the proceeds from the tree will be shared among the contenders. A third person is asked to collect and sell all the fruits from the tree and hand the money over to the chief. This caretaker is given a portion of the money as payment for the job and the warring parties share the rest. All these punishments serve as deterrent to troublemakers and criminals in the community and so bring peace to the people.

Transportation: There are only a few means of transport available to the people, *viz.* trekking on foot and canoeing for the people that have access to the rivers that form part of the distributaries of the river Niger. There were no cars, lorries, bicycles or even animals not to talk about aeroplanes. Every load that has to be transported on land must be carried on the head. If the load is big, it has to be shared and carried by many people. If it is something that could not be shared into smaller portions, or rolled along on the ground then it should be abandoned.

If the distance to be covered from one point to another is very long the journey has to be made over many days. When the people undertaking the journey get to a village just before dusk, they will seek out the home of the chief and go to sleep there; the following morning at the first crow of the cock they will continue their journey. The chief must show them hospitality so that his own people will be shown hospitality by other communities. The chief's youngest wife must cook good food for the travelers and they must be given a comfortable place to sleep. It is an act of declaration of war if travelers are attacked on their way by any community; travelers must be protected and it is the duty of the community through which they are passing to provide them security until they enter another community. This is important because in those days people are kidnapped and sold into slavery or sold to people that will dedicate them to their idols (*so that they become outcasts*) or even sacrifice them to their idols. So if any group of travelers disappears on the way, the community where they disappeared will be held accountable and this could lead to war.

When a very sick person, who cannot walk is to be taken to the home of a traditional healer, his bed is used to carry him; two strong men will carry him while lying in his bed.

The people, who have access to the rivers use dugout canoes as an additional means of transport. They use it to go far into the jungles to tap palm wine from the raffia palms that are in abundance there, to fish, to work in their farms or to visit the neighbouring communities

separated by the rivers. These canoes are used to transport goods and people as a means of livelihood for the canoe owners. The big canoes that have shelters over them undertake journeys that last up to many weeks. The travelers cook and eat their food inside the canoes. At night they may decide to continue their journey; in which case they take turns to paddle the canoe (while some are sleeping others are paddling the canoe) or they may decide to park it somewhere and go ashore to sleep and to continue the following morning. If they park near a village they will sleep with the villagers in their homes but if they park where there are no people, they have to clear an area and make a big fire and sleep by the fire. The fire will warms them and also drive away wild animals.

Miscellaneous:

There are no schools and so no formal education. The young ones learn from the adults by imitation and through story telling. Storytelling serves as a means of inculcating morals into the youth and also as a means of preserving the peoples' culture and tradition. It also helps to pass on the history from generation to generation as there was no written record.

Every adult in the community contributes to the training of a child whether his or those of his neighbours. Newly married women learn from the older wives how to manage their family.

Clocks and watches are not in existence, time is estimated by the use of personal shadows; when the sun rises in the morning it is six o'clock, when a person stands on his shadow it is midday and when the sun is setting it is six o'clock in the evening. The length of the shadow relative to the landmark times estimates any other time in between those mentioned here. The age of individuals is estimated with landmark events like the world wide influenza of 1918 and the destroying of the people's guns *(Itiji egbe)* by the British in 1910. When the British arrived in Igboland by the turn of the twentieth century

they found that the people were hunters using their locally made guns and bows and arrows. They became afraid that those people might one day revolt and attack them and so they tricked them into gathering their hunting weapons at a designated place in exchange for tobacco or hot drinks. They later on destroyed and burnt all of them; that happened in 1910.

There are no cars, bicycles, horses or donkeys, every journey is made on foot and every load is carried on the head. Sick people are strapped on the back when taking them to the traditional healer or alternatively two strong men carry the person in his bed. In the case of a heavy load to be transported over a long distance people take turns to carry it until they reach their destination.

If a community leader wants to get message across to his people he uses the town crier to go round the village and inform the people. If he wants to send messages to his counterparts in other villages he uses messengers to get his messages across. An elder person uses young people to send messages to other people.

This was how things were organized in the village before the advent of the western civilization.

www.ingramcontent.com/pod-product-compliance
Lightning Source LLC
Chambersburg PA
CBHW021019180526
45163CB00005B/2028